Coloring With Steve
Color My Tangles

Inside we have some very cool designs for your coloring enjoyment.

So grab your coloring pencils, sit back and let's get started Coloring With Steve.

Will be posting colored photos, shading tips and Ideas on our Website also.

coloringwithsteve.com

Be sure to like us on Facebook
www.facebook.com/coloringwithsteve

Tell your friends and family where to get their own copy below:

coloringwithsteve.com

By Steve Jennings

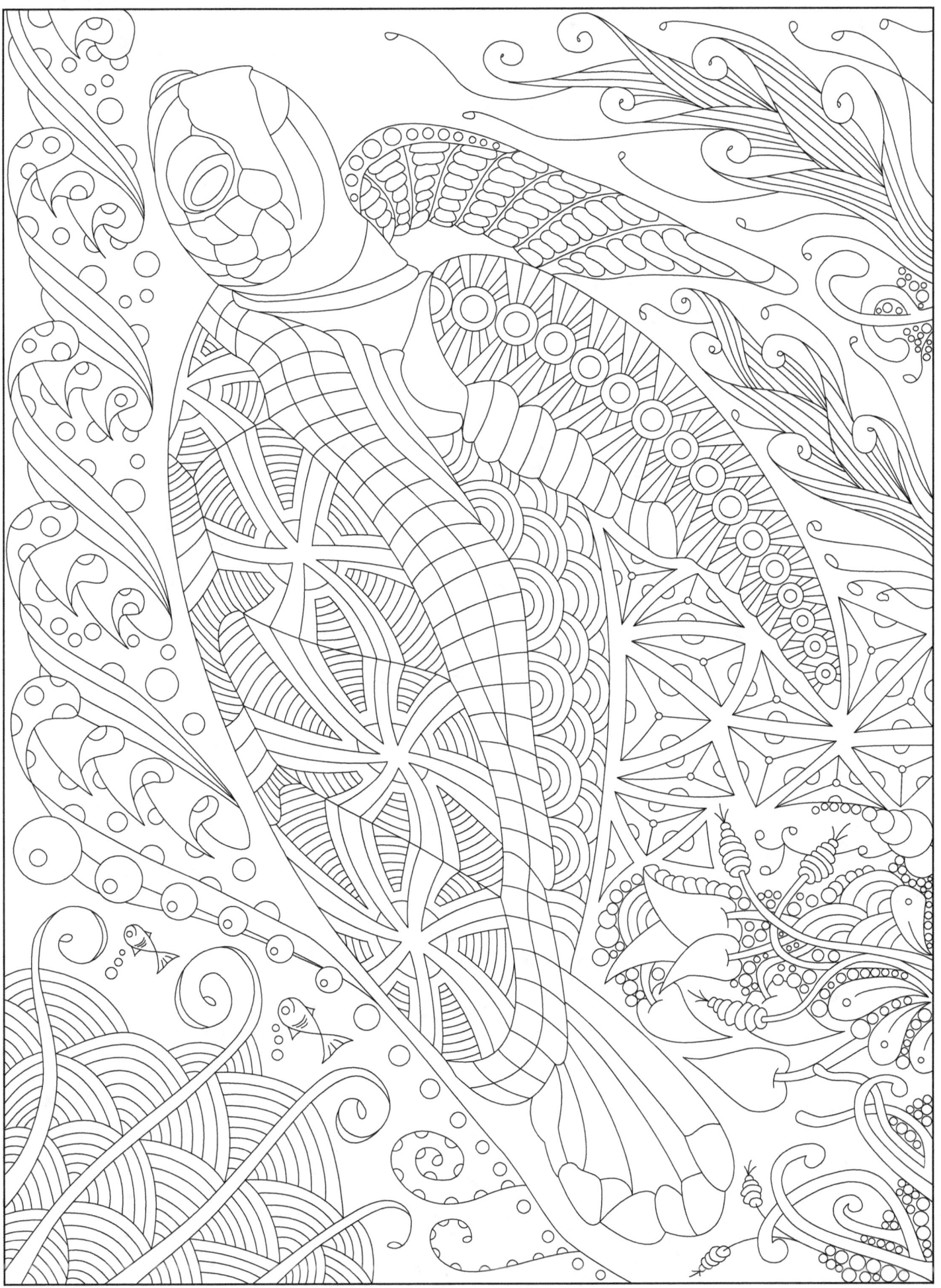

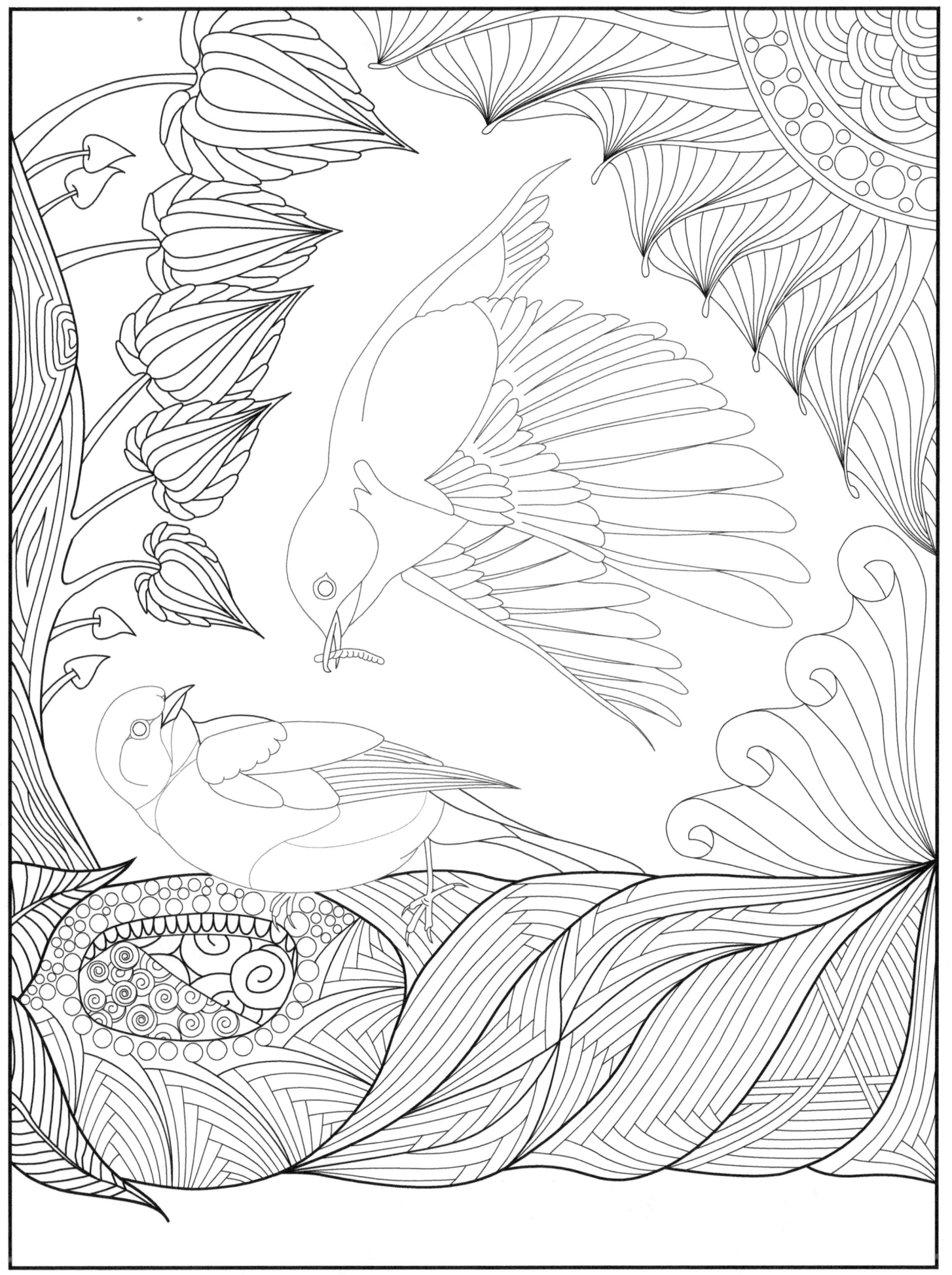

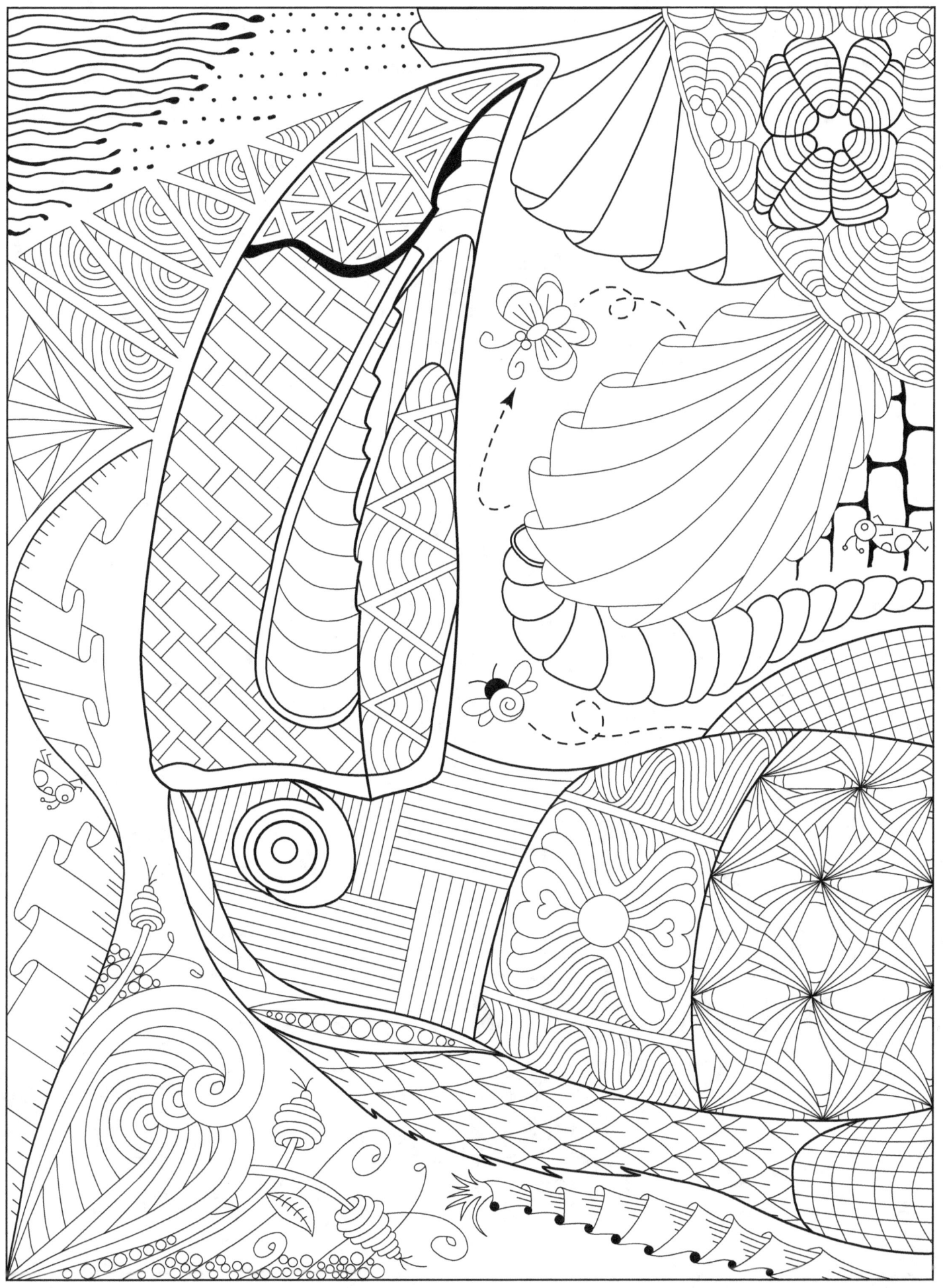

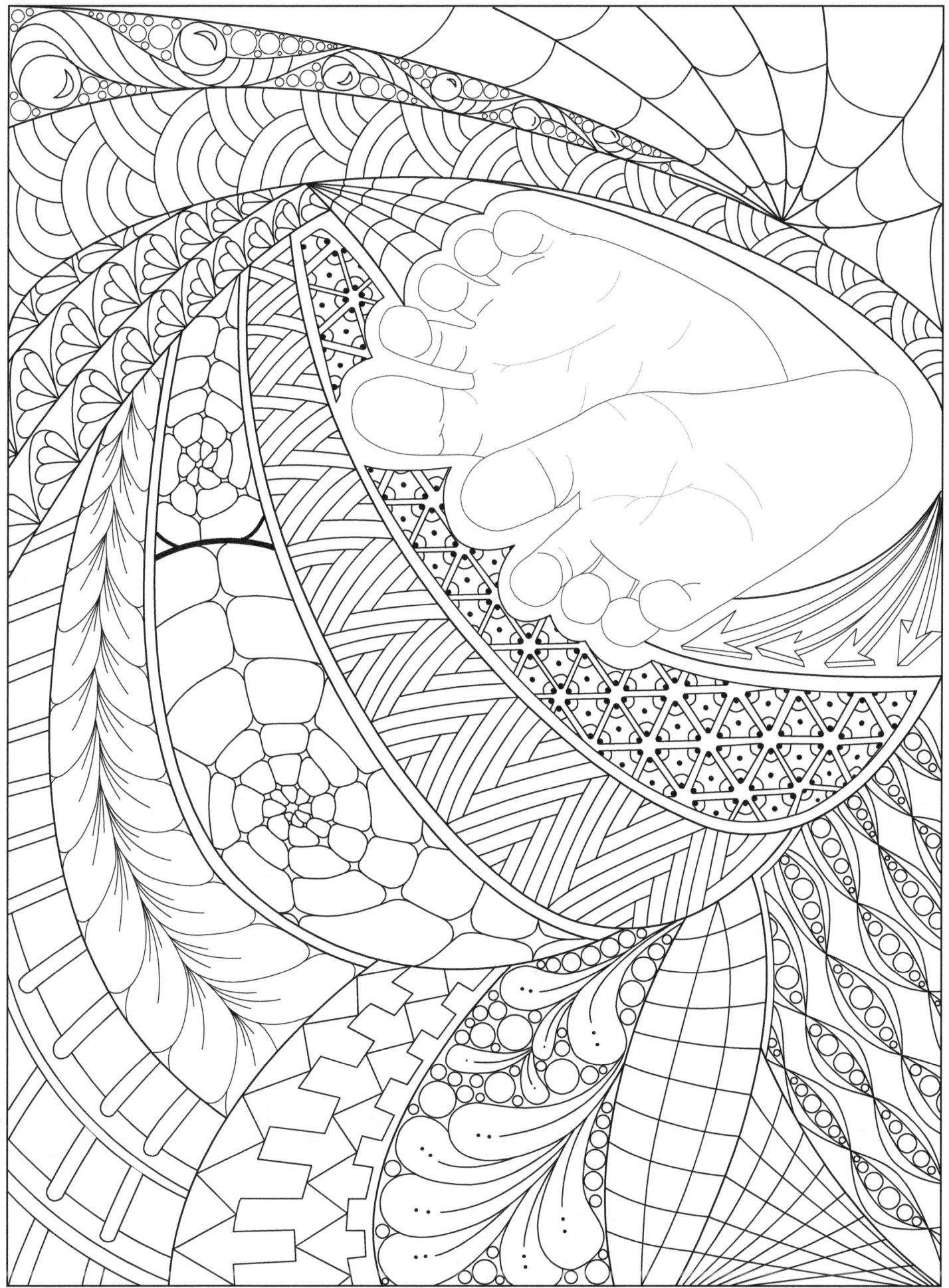

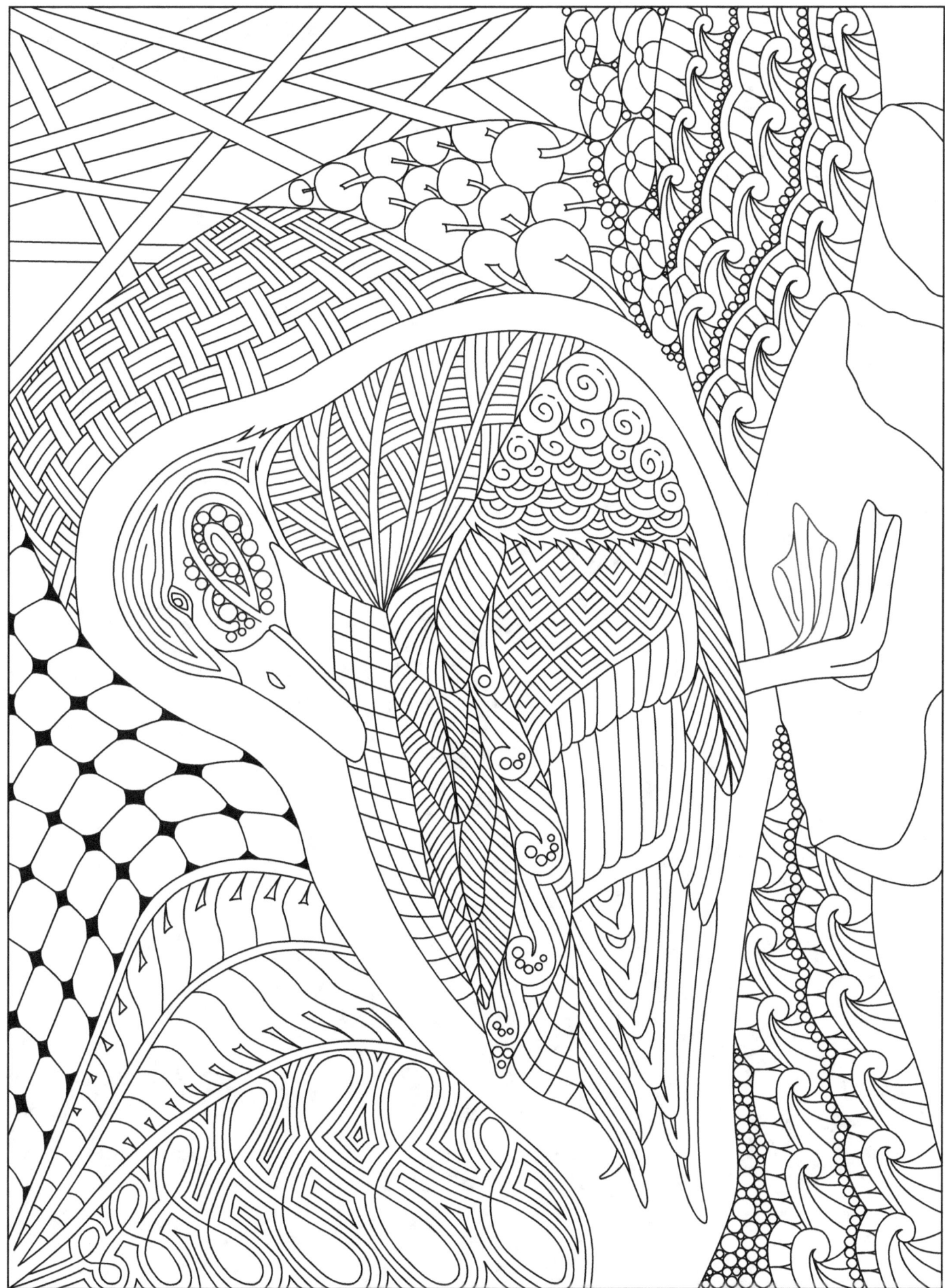

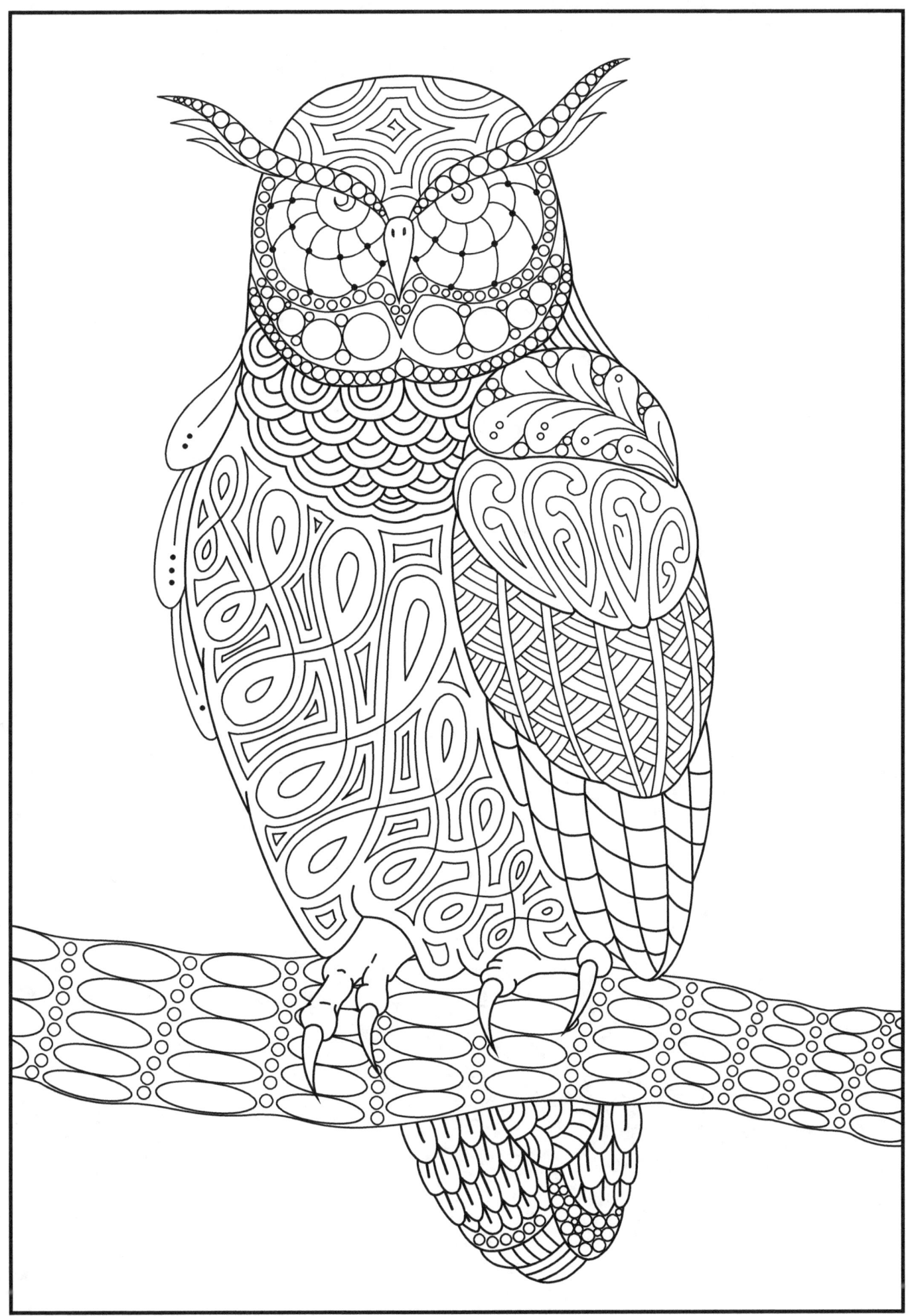

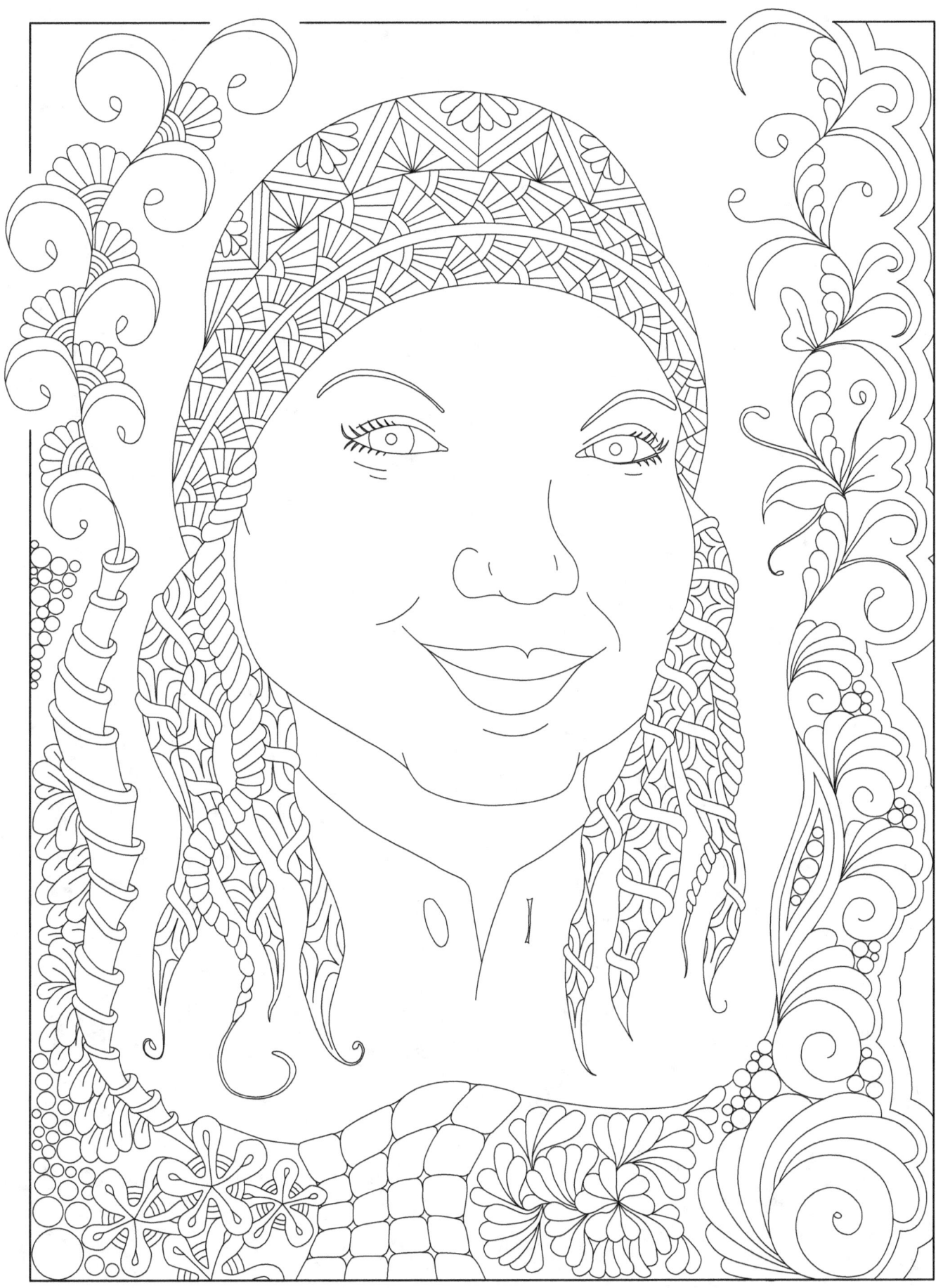

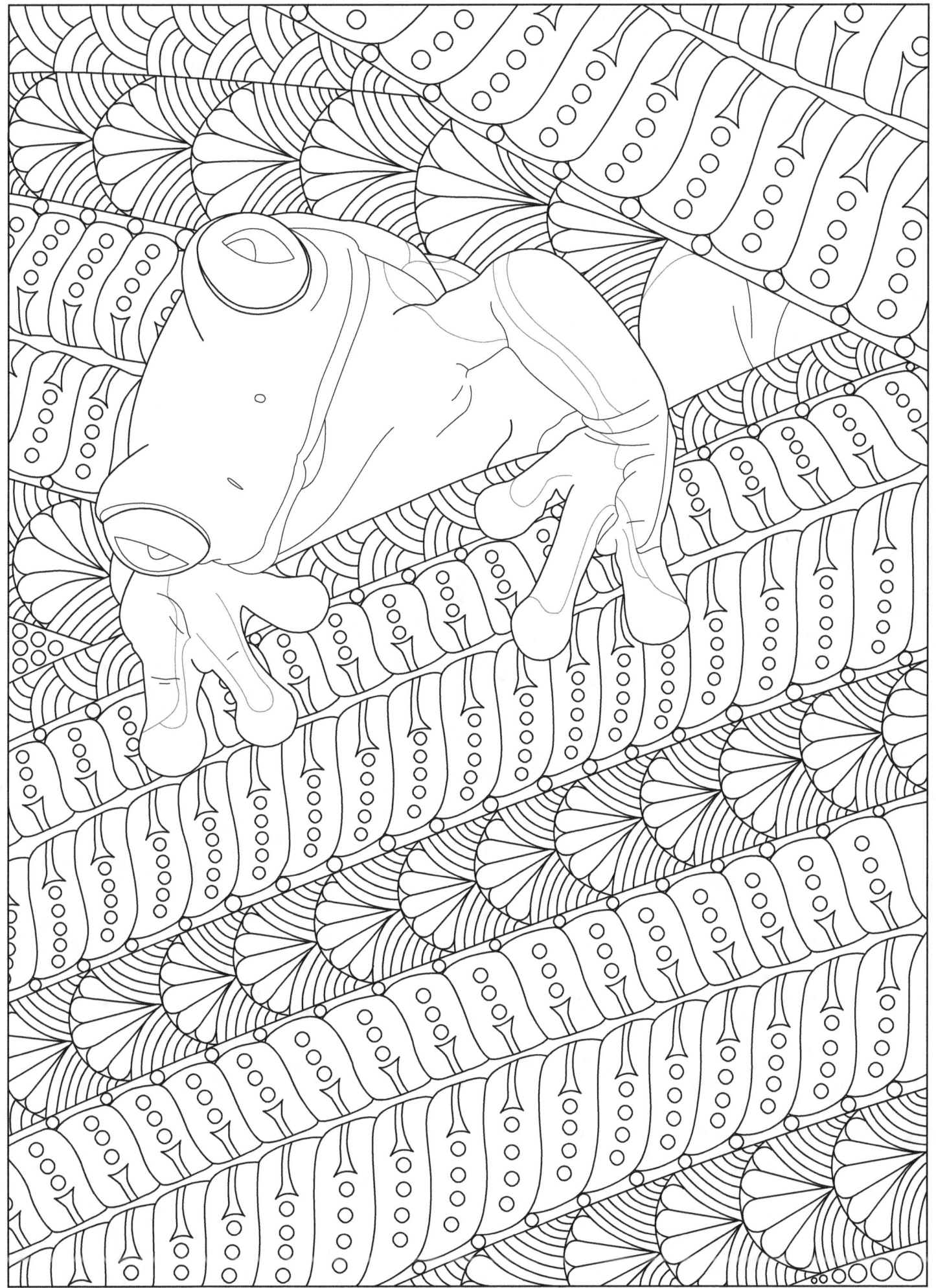

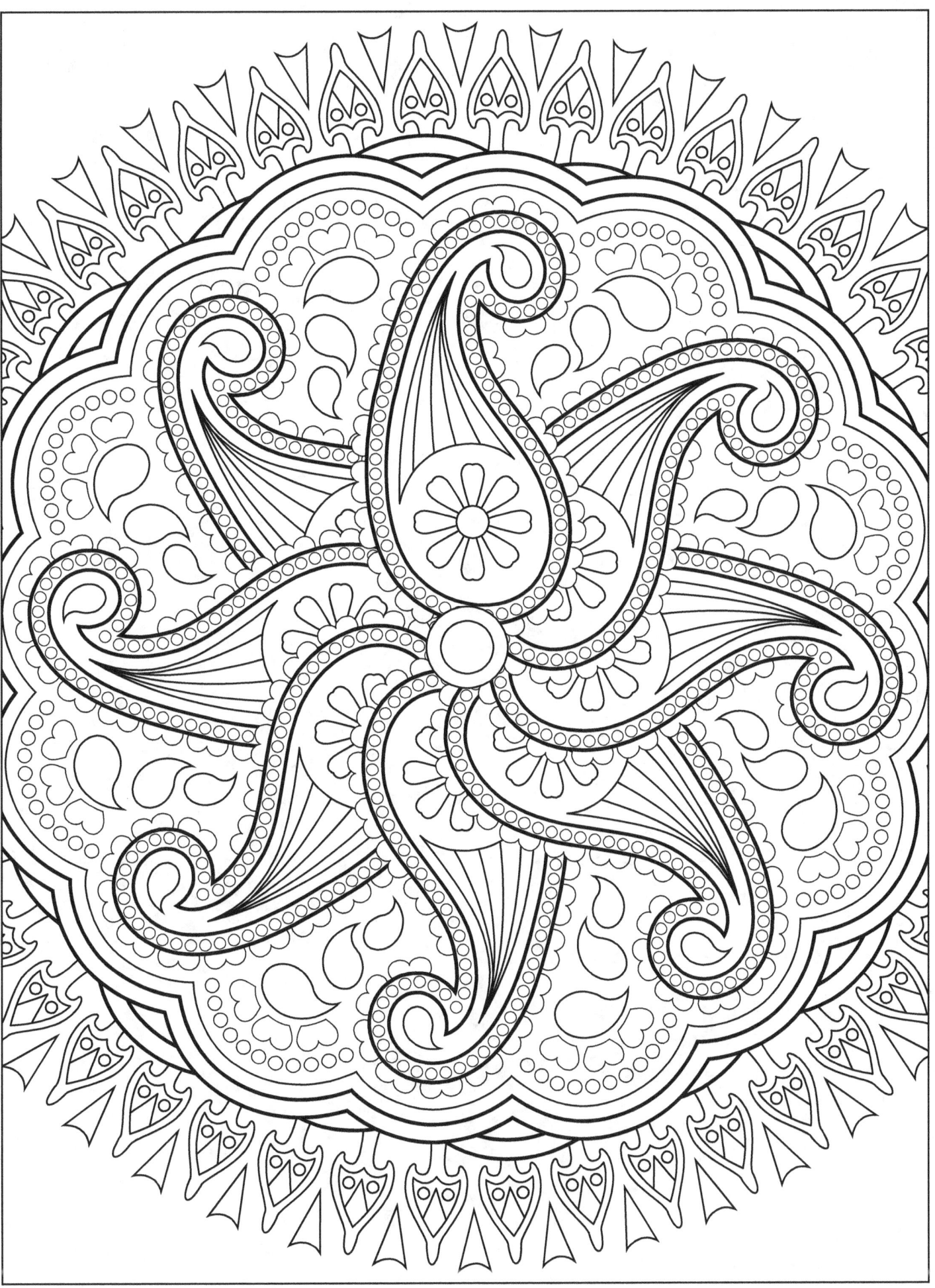

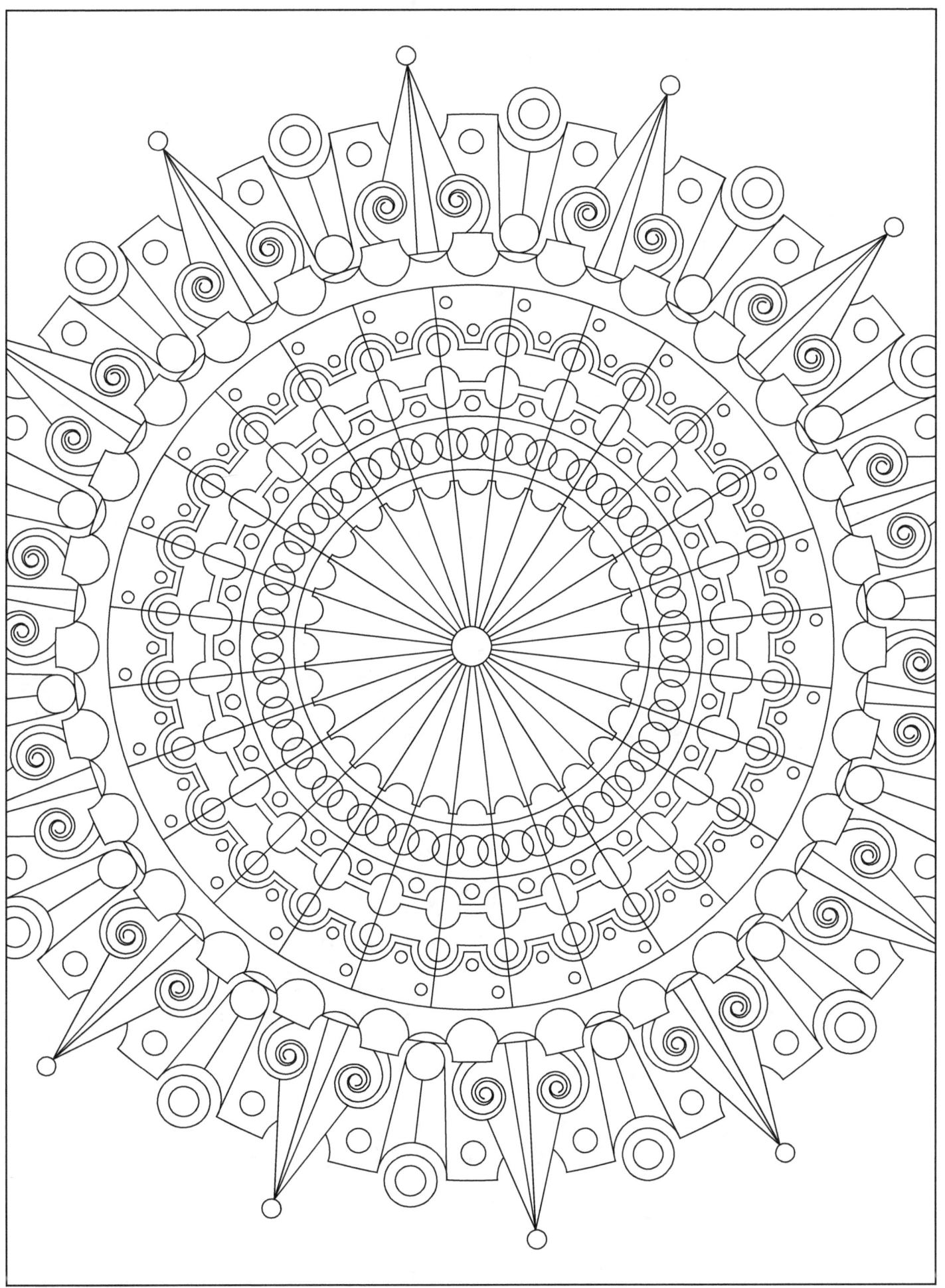

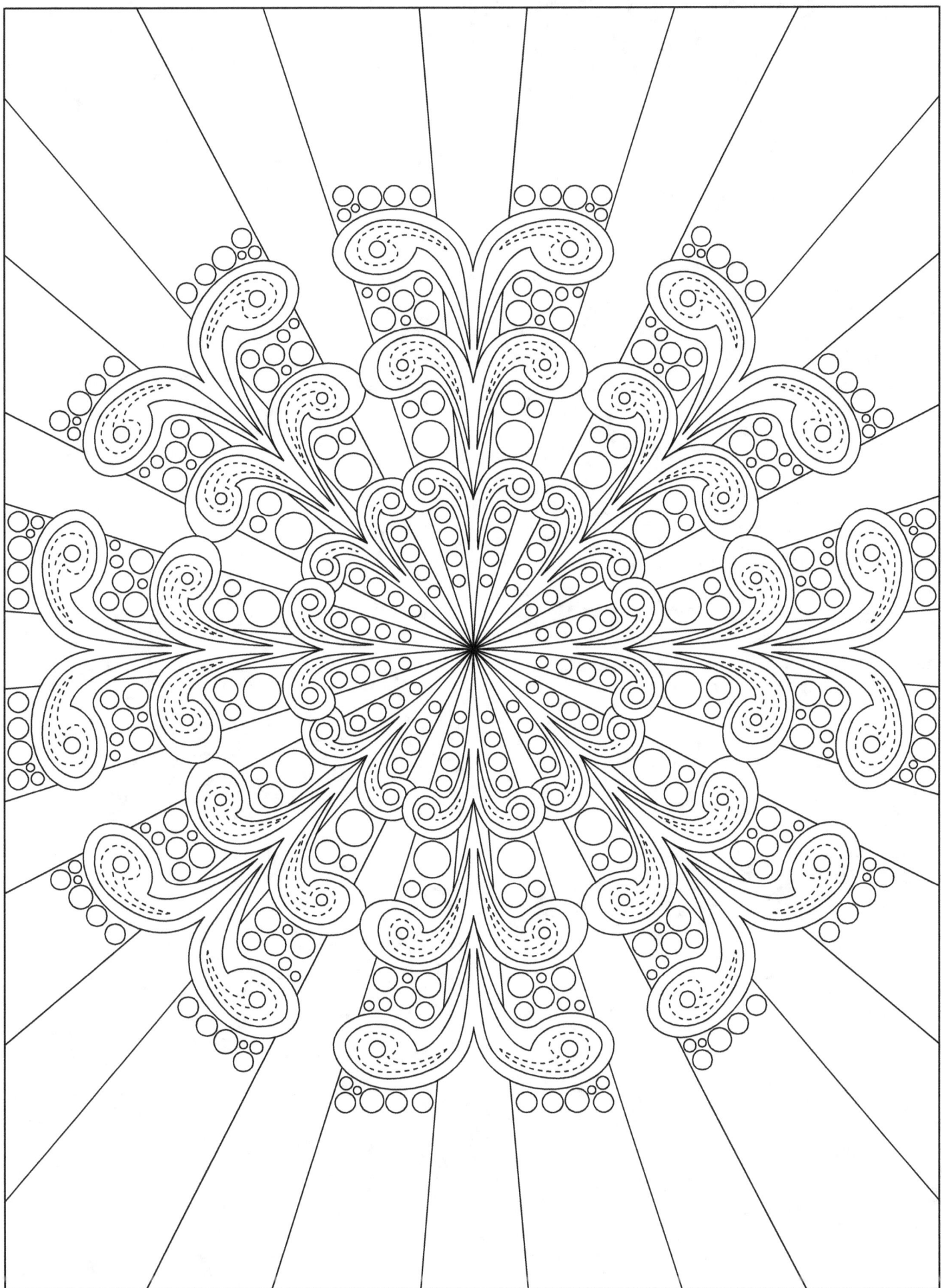

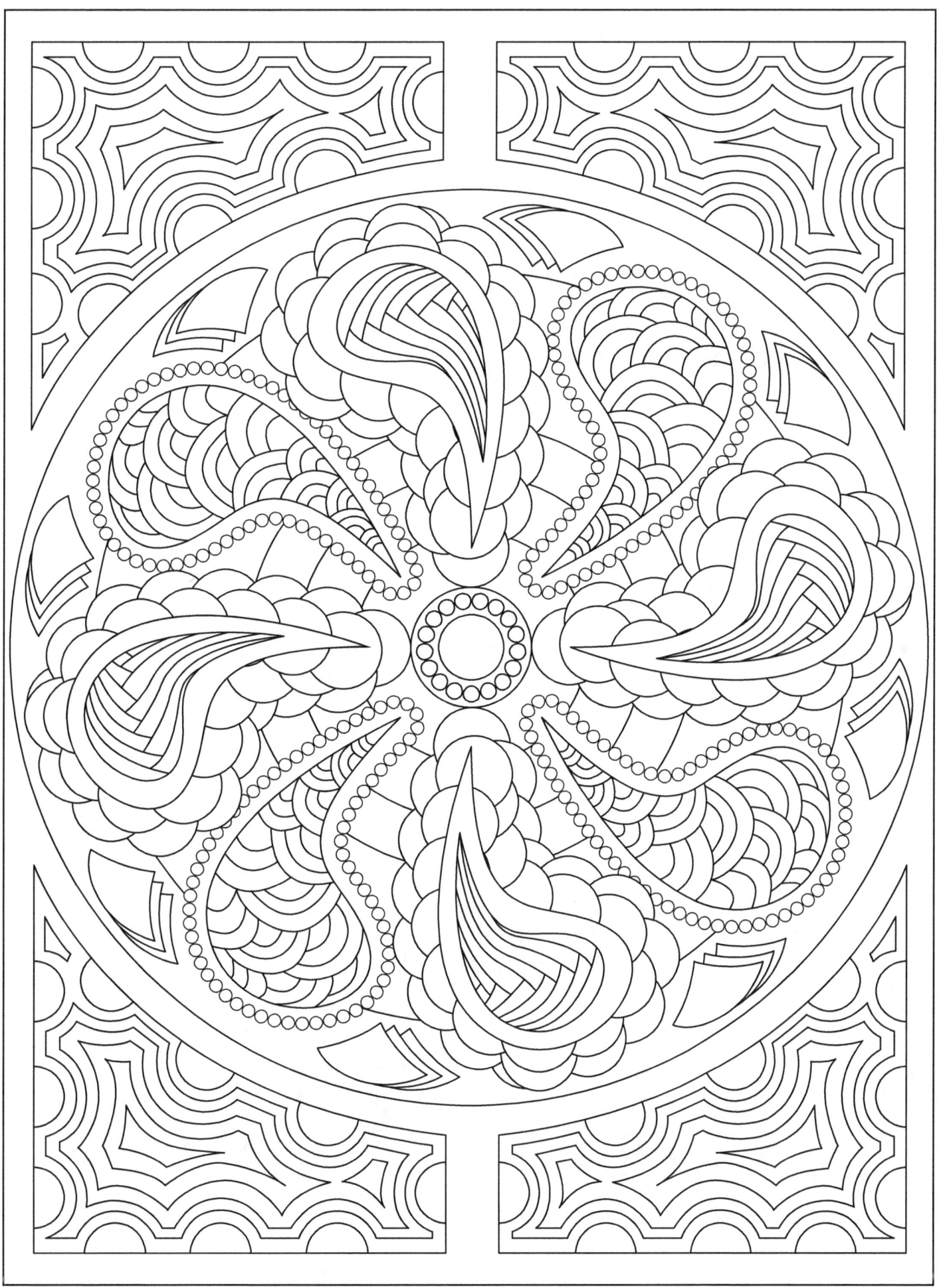

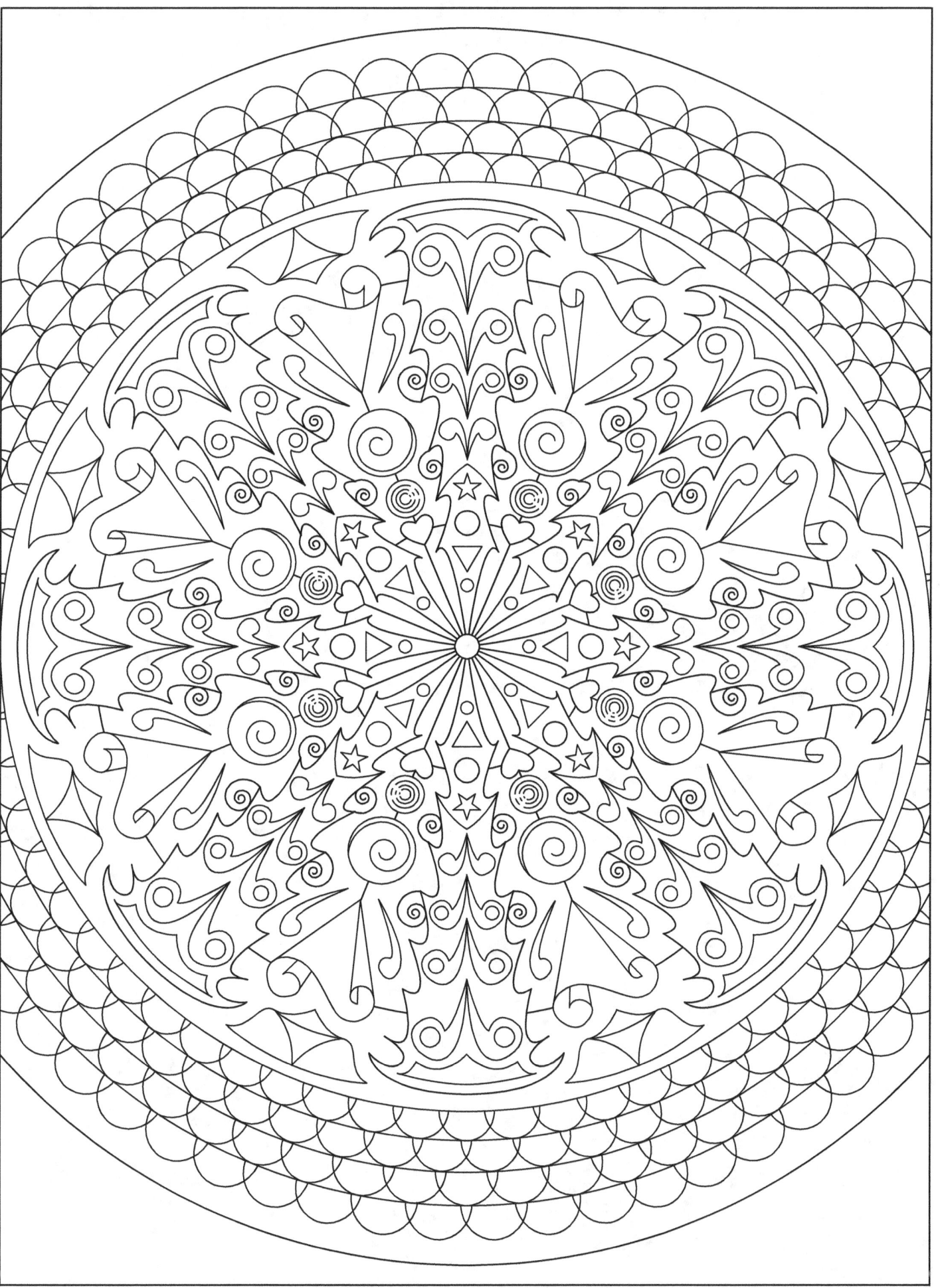

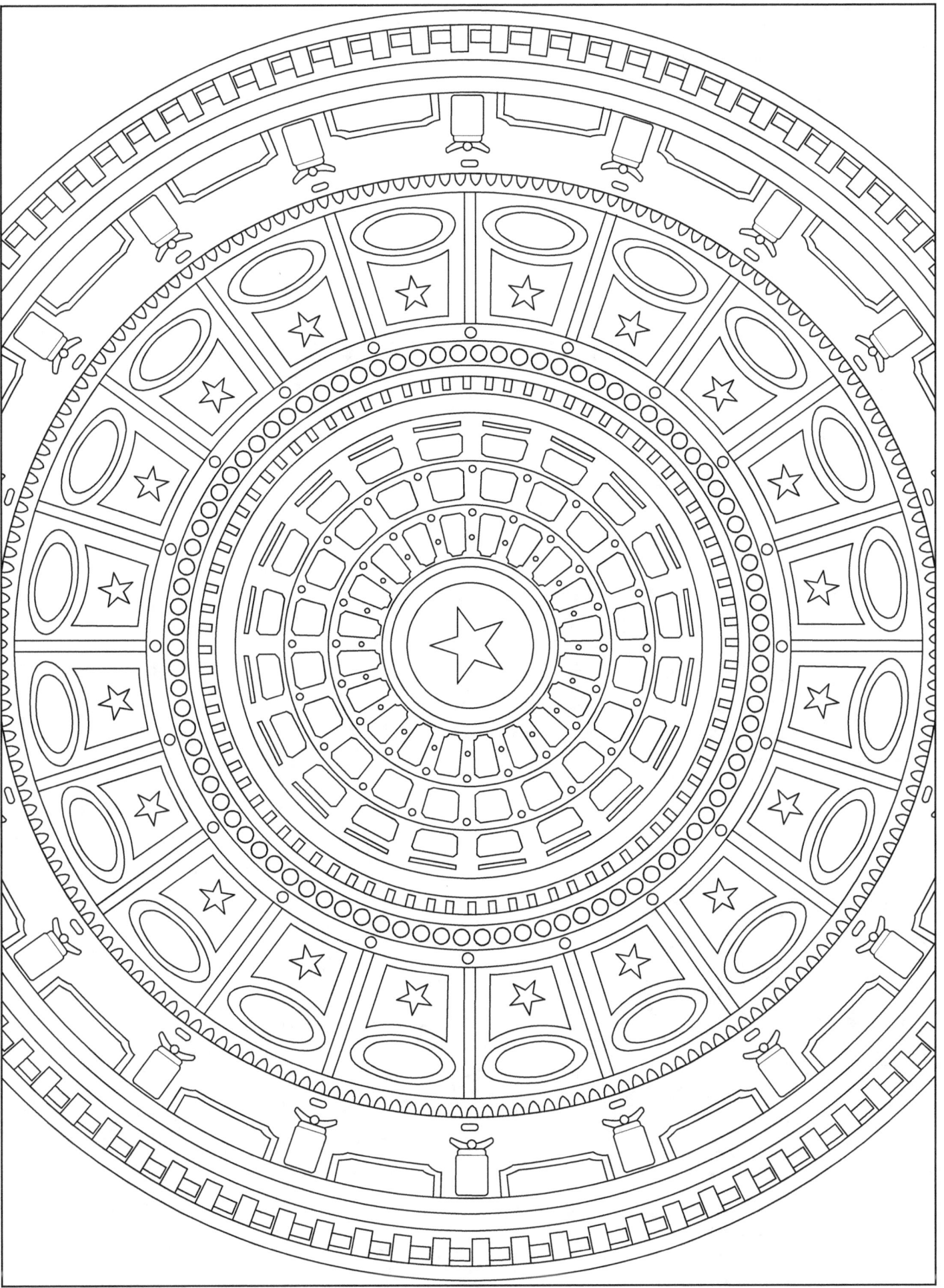

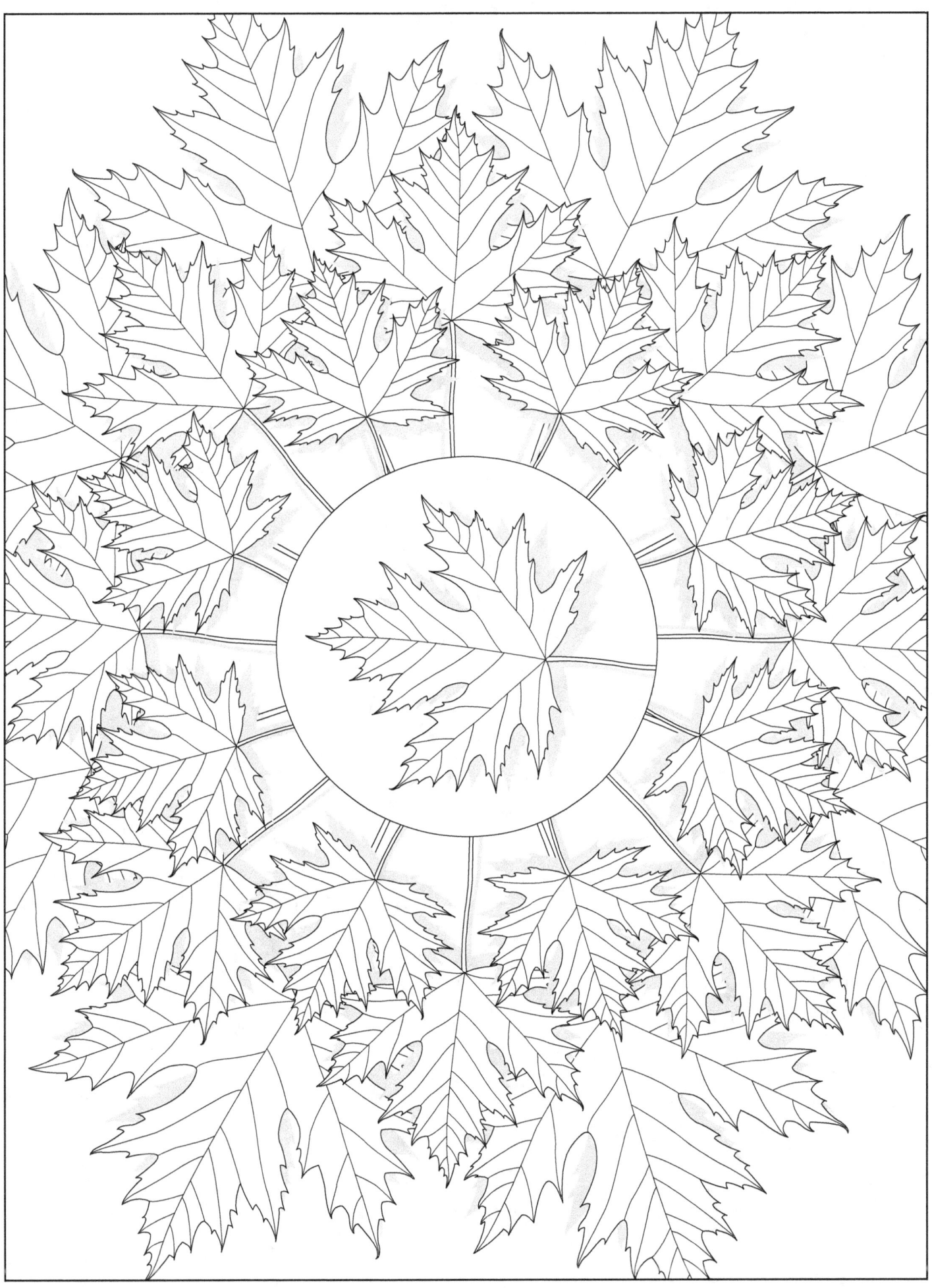

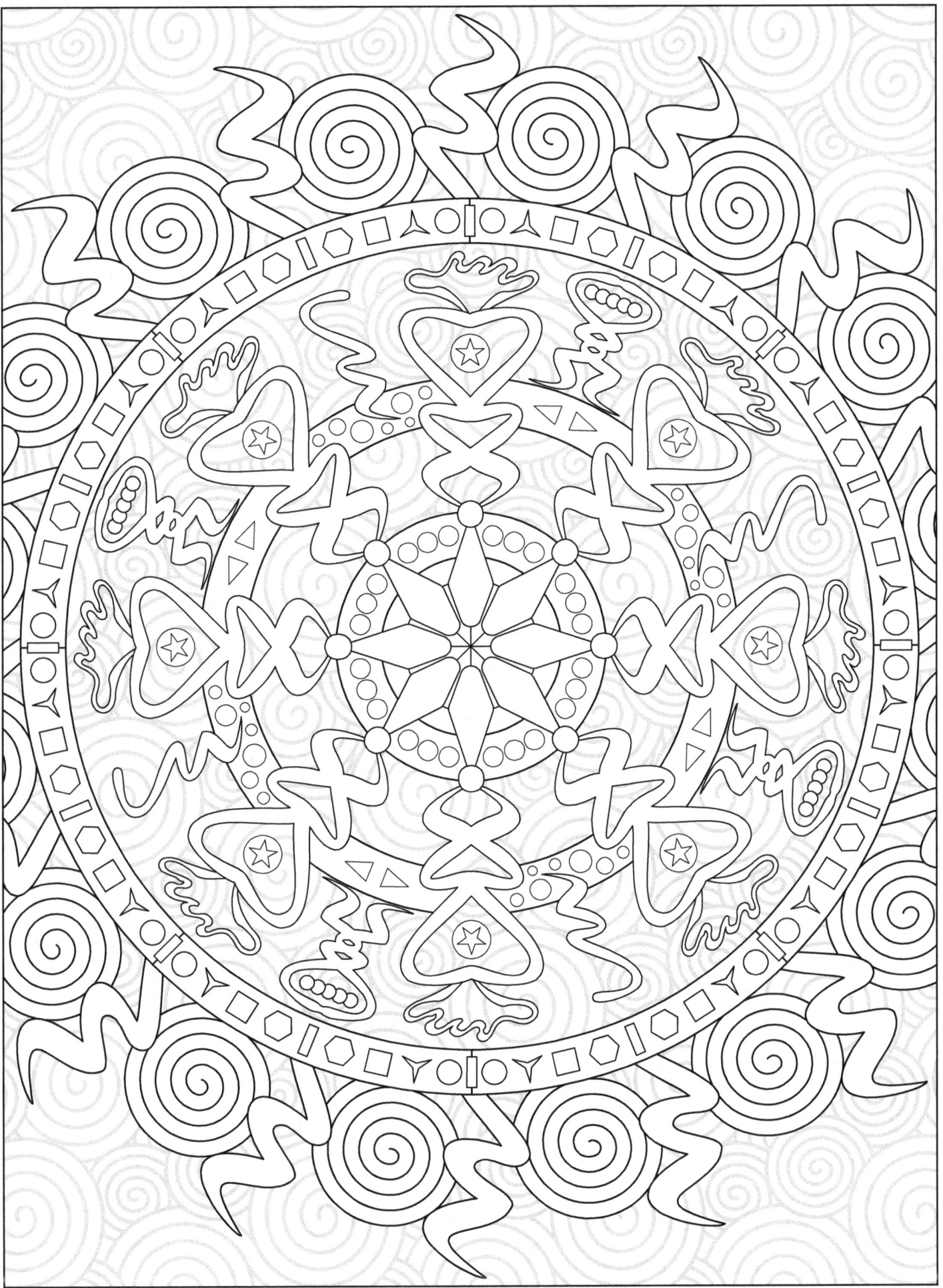

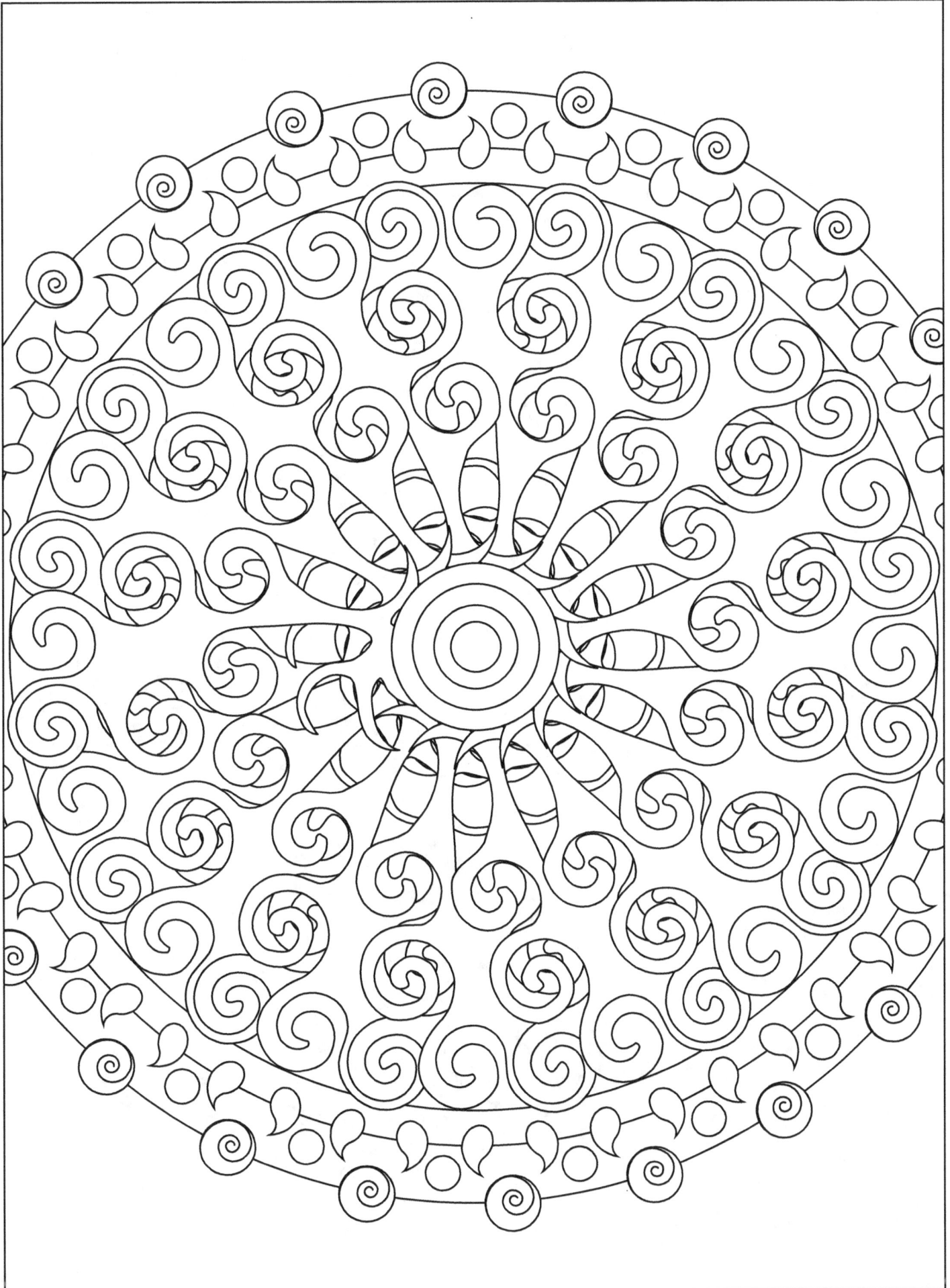

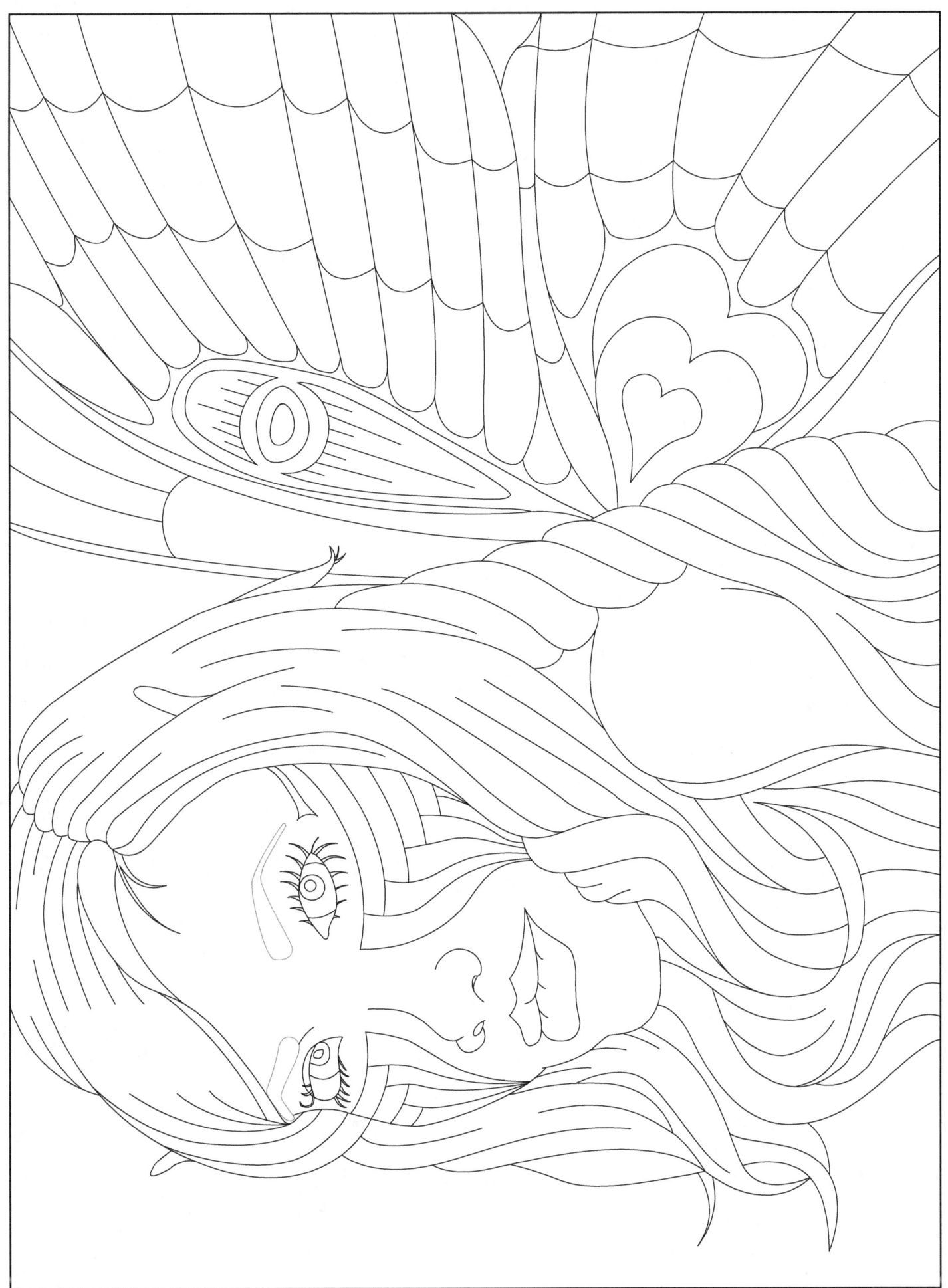

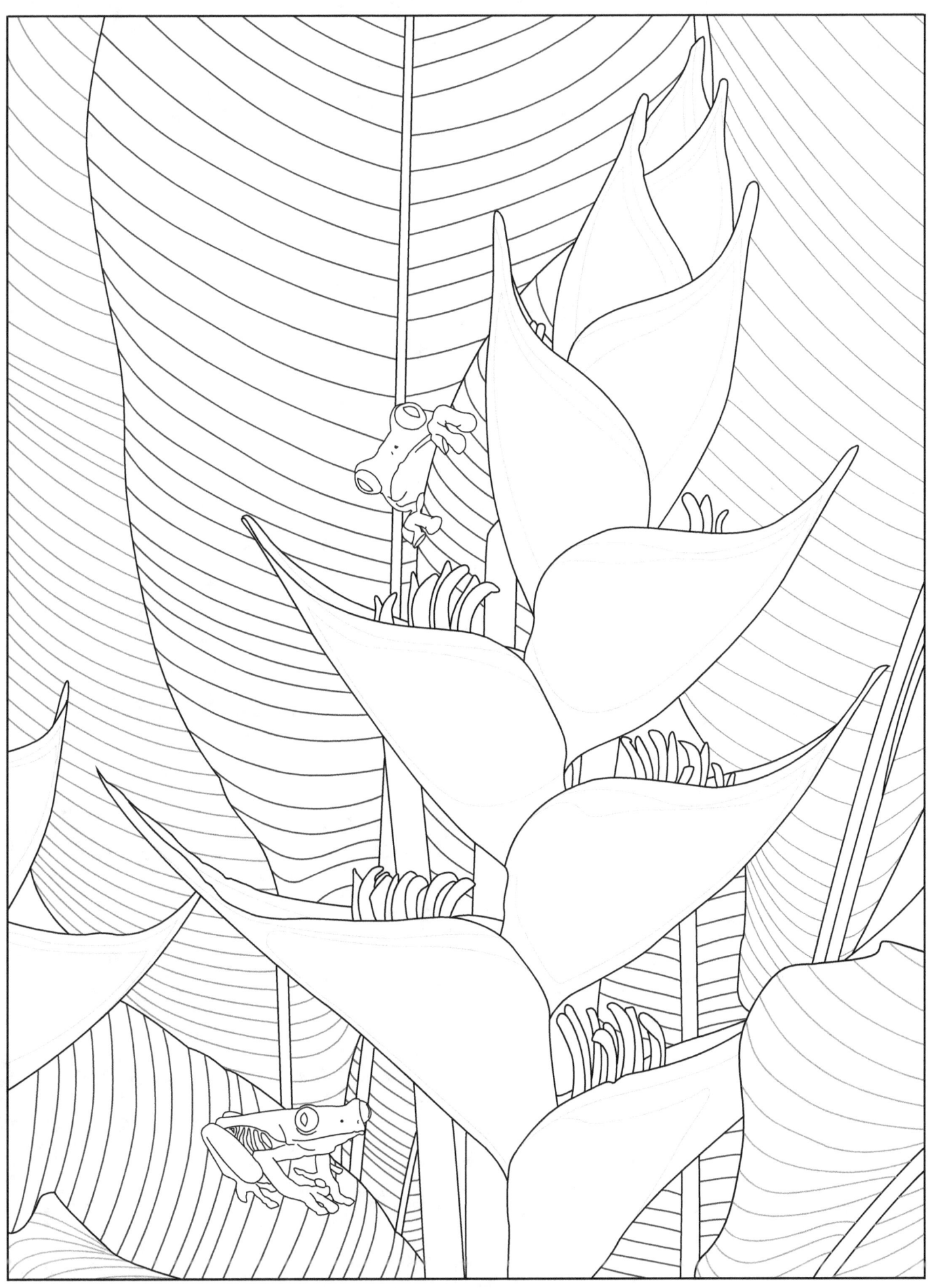

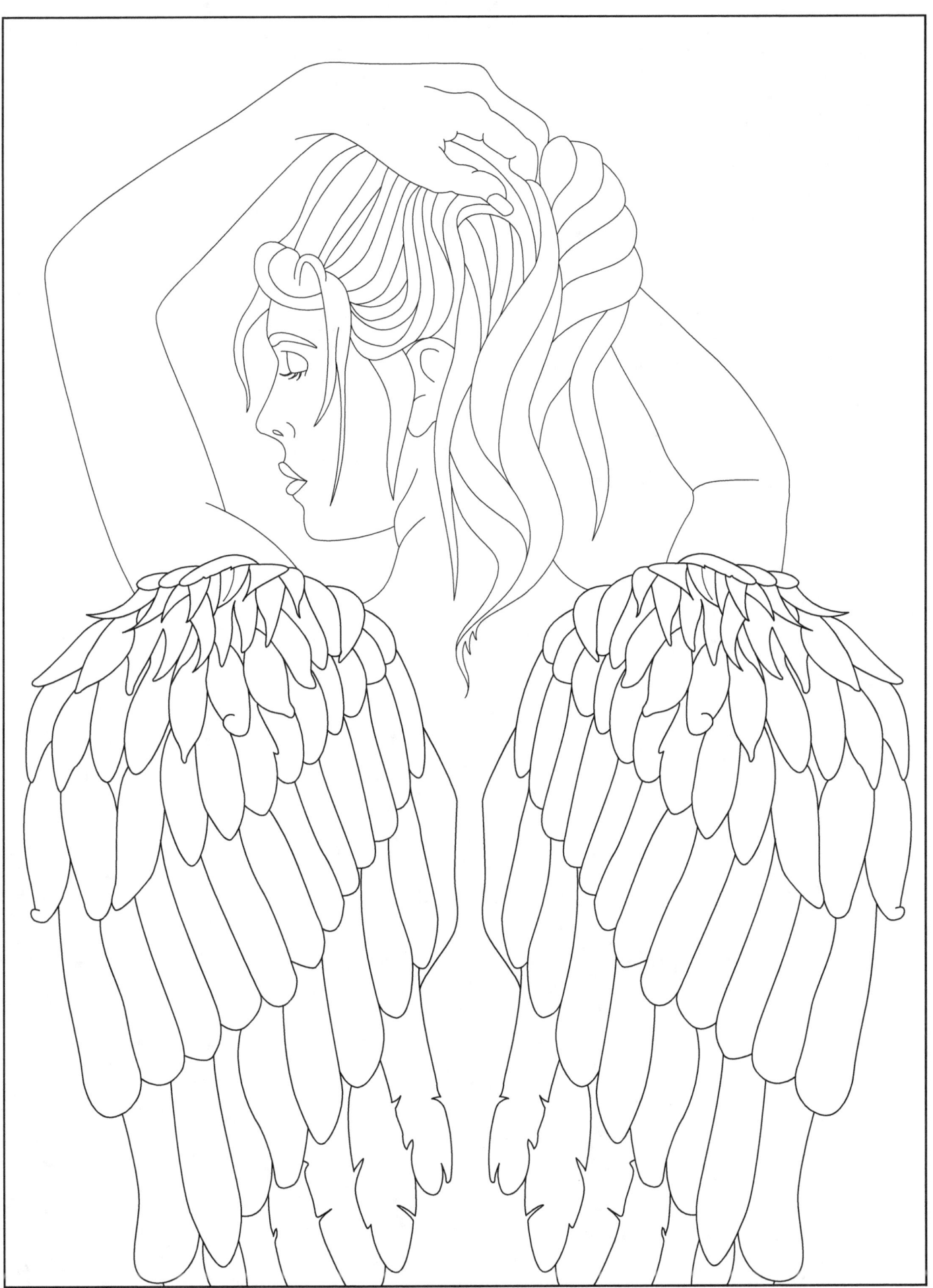

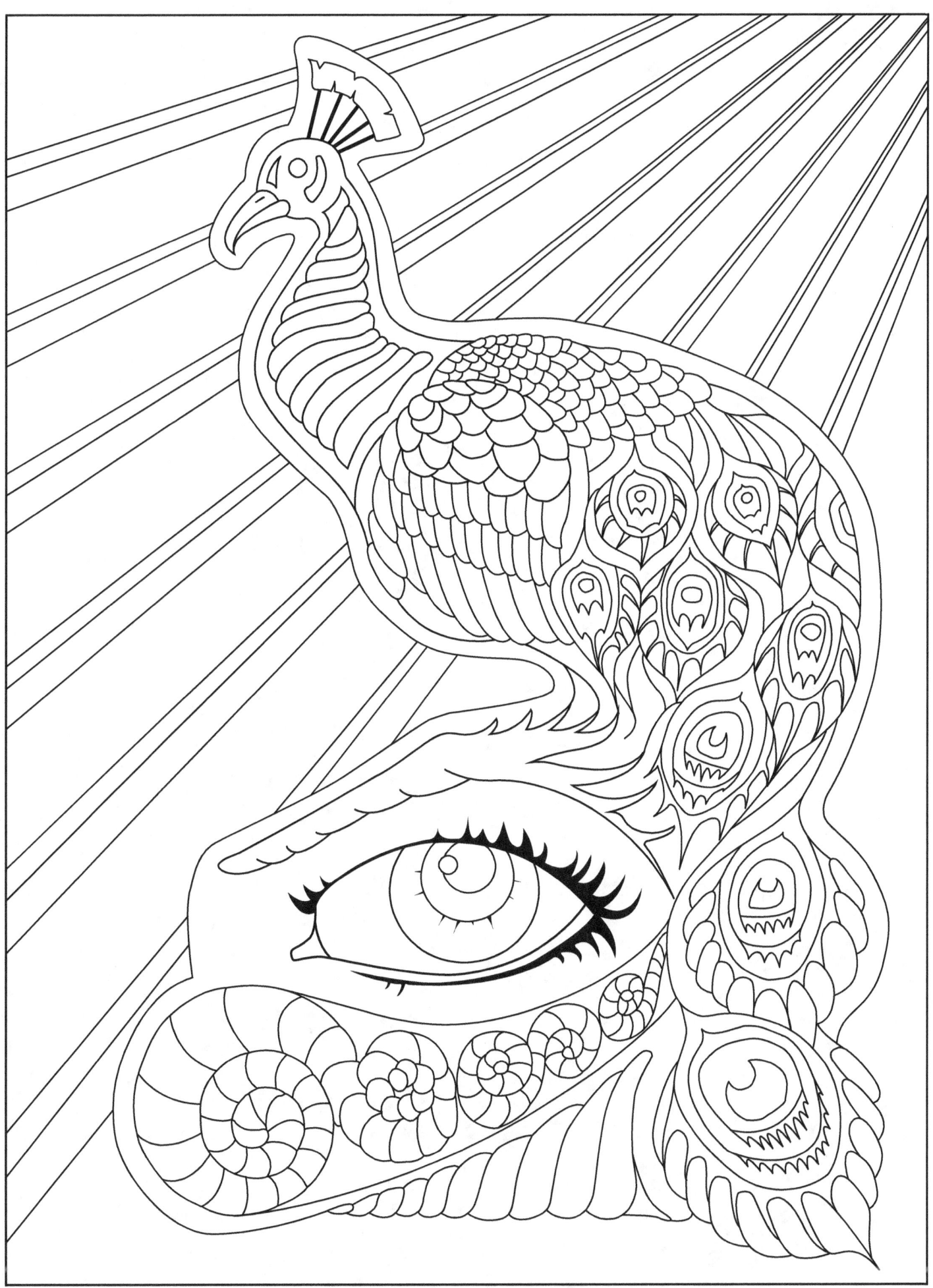

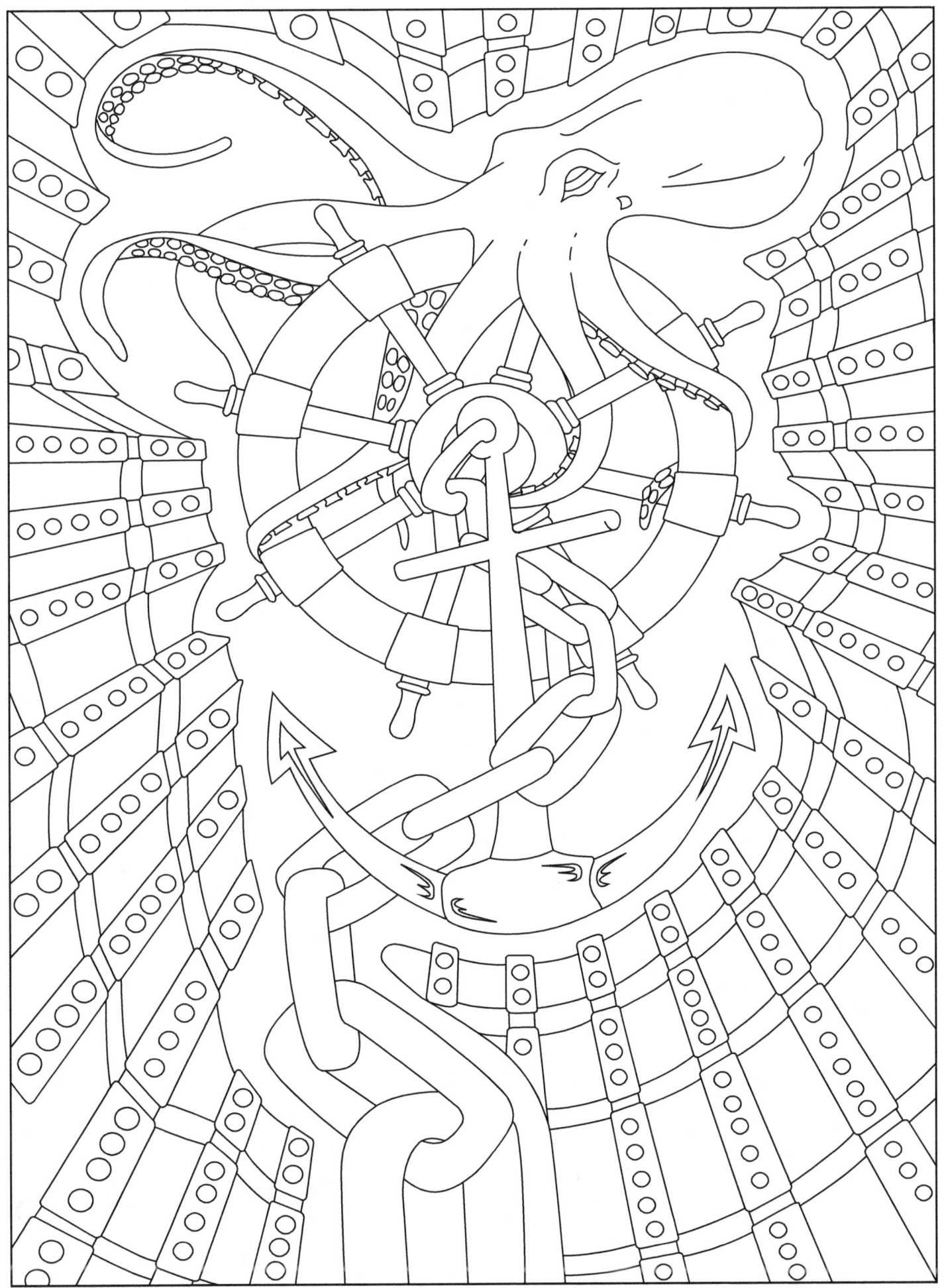

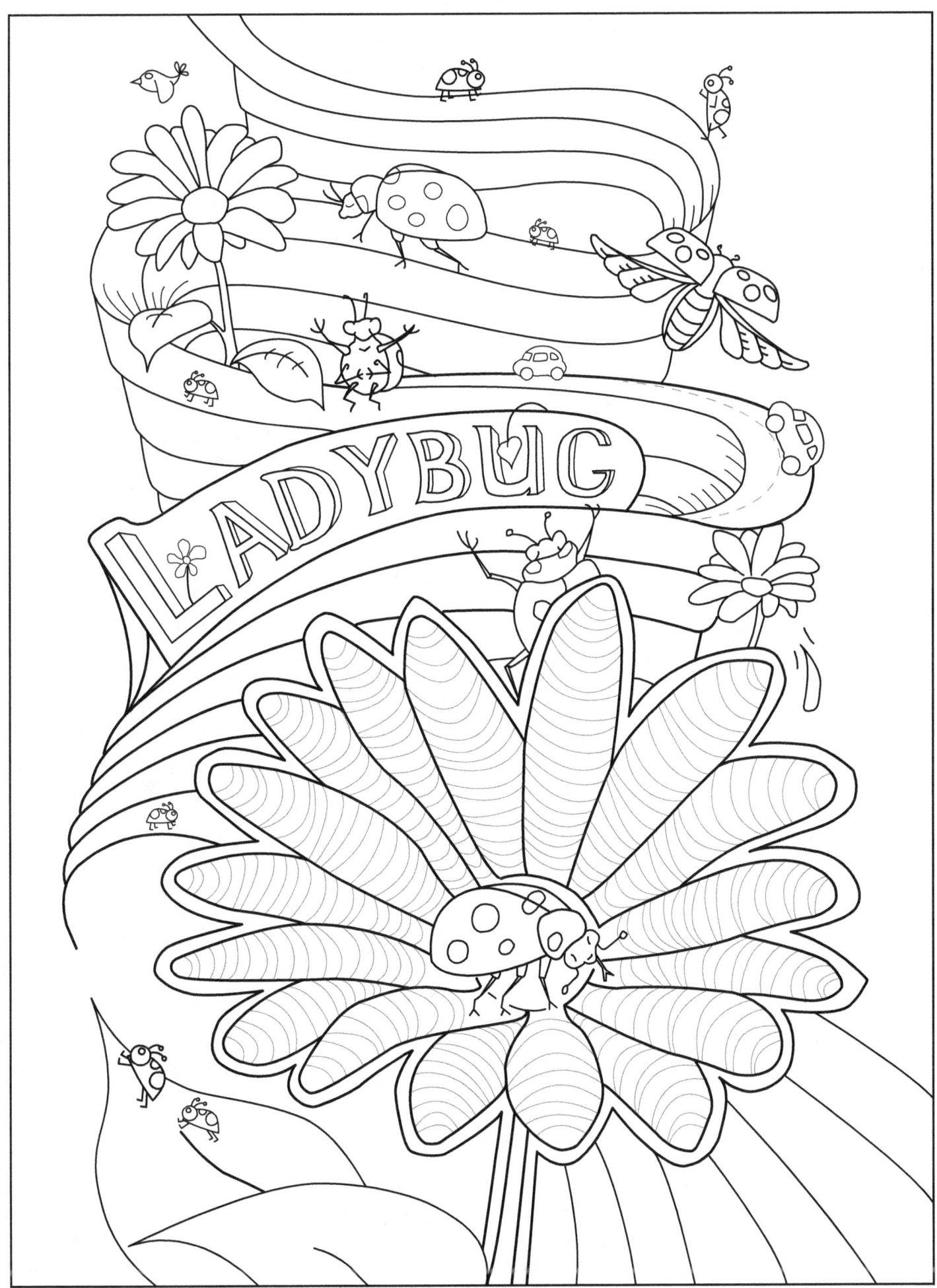

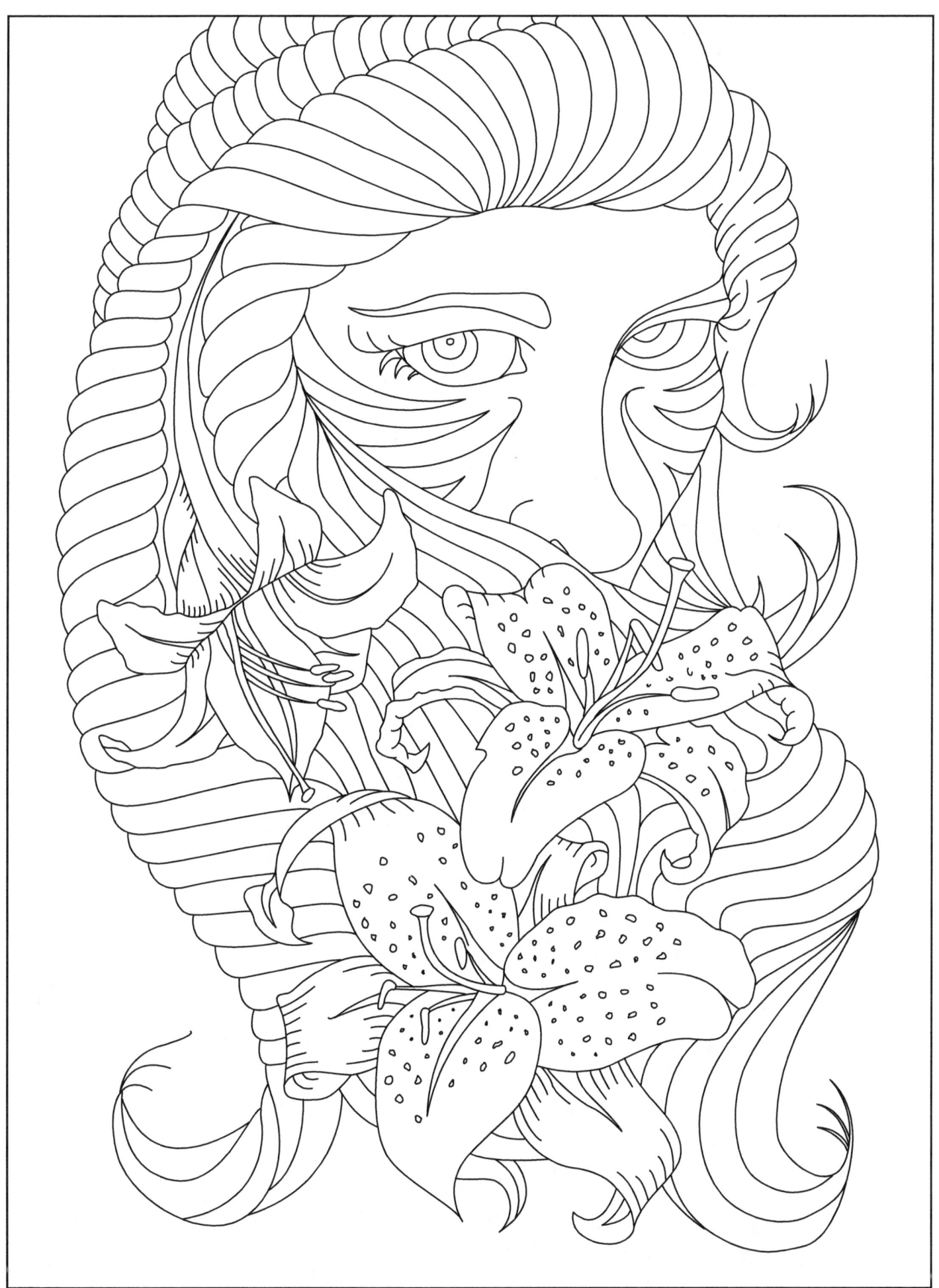

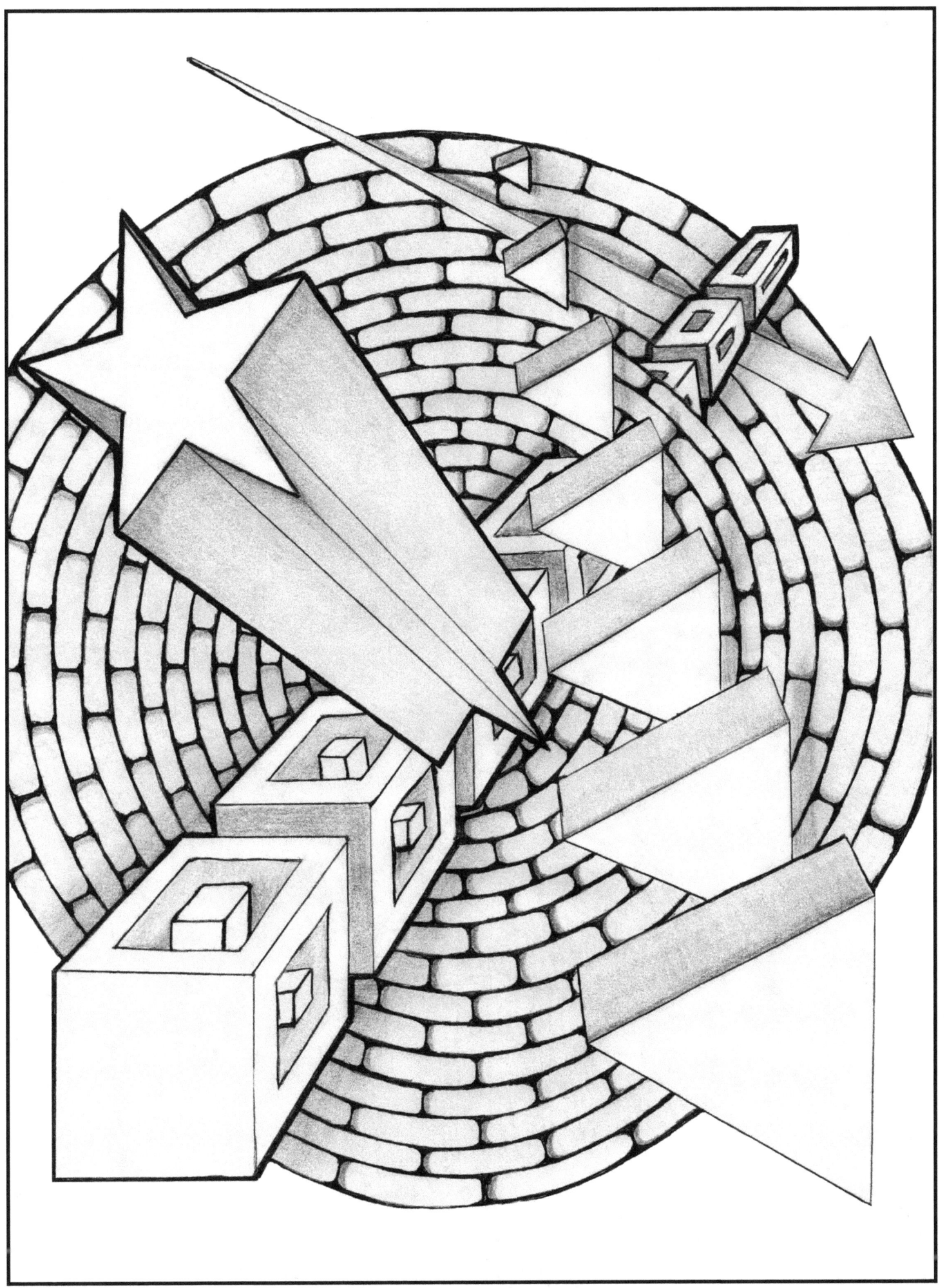

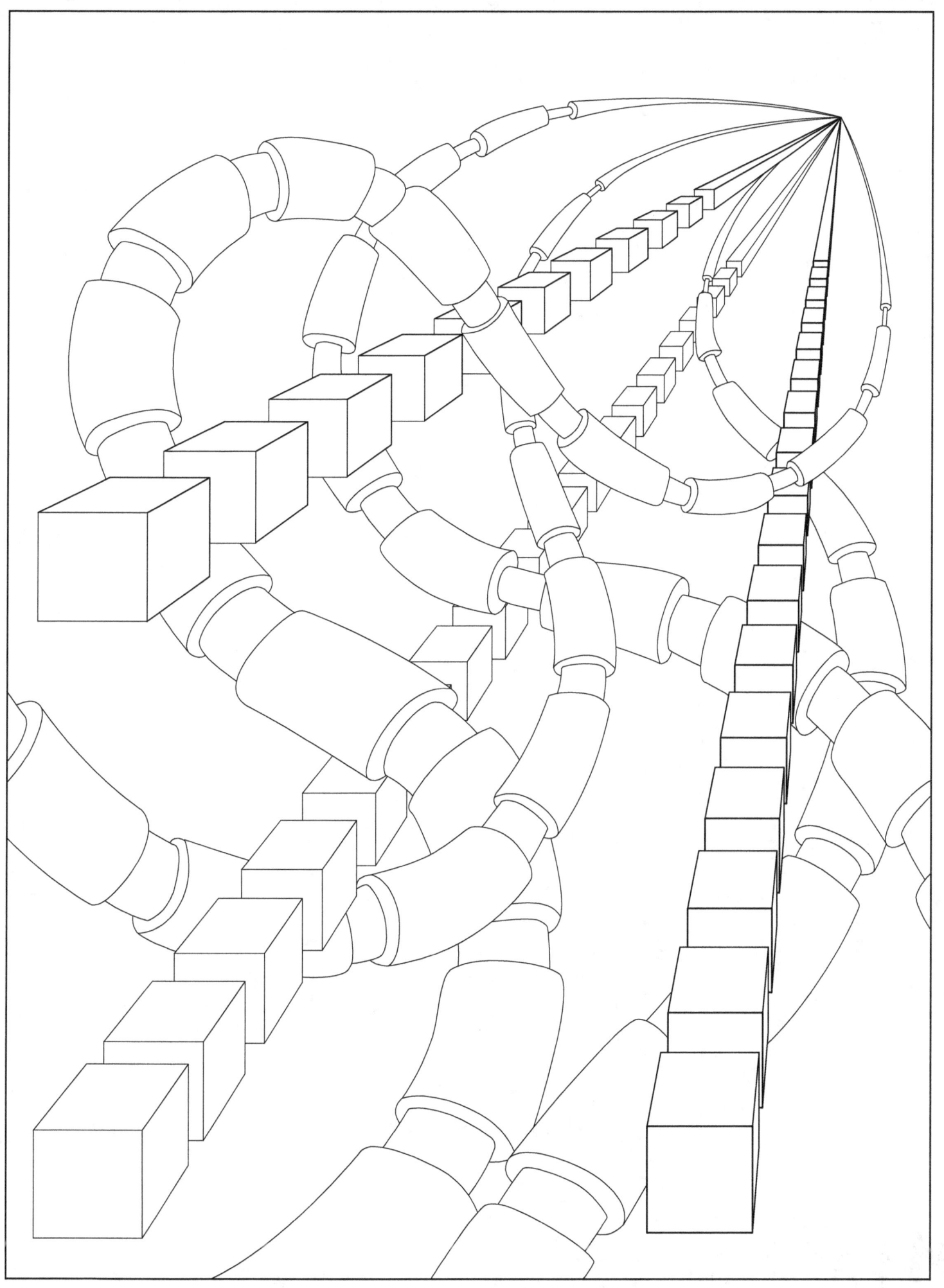

www.ingramcontent.com/pod-product-compliance
Lightning Source LLC
Chambersburg PA
CBHW081250180526
45170CB00007B/2359